Mandala
Leisure Arts Coloring Books

Copyright: Published in the United States by Cathy Osterberg
Published December 2016
ISBN-13: 978-1541224490
ISBN-10: 1541224493

All rights reserved. No part of this publication may be reproduced, stored in retrieval system, copied in any form or by any means, electronic, mechanical, photocopying, recording or otherwise transmitted without written permission from the publisher. Please do not participate in or encourage piracy of this material in any way. You must not circulate this book in any format. Cathy Osterberg *does not control or direct users' actions and is not responsible for the information or content shared, harm and/or actions of the book readers.*

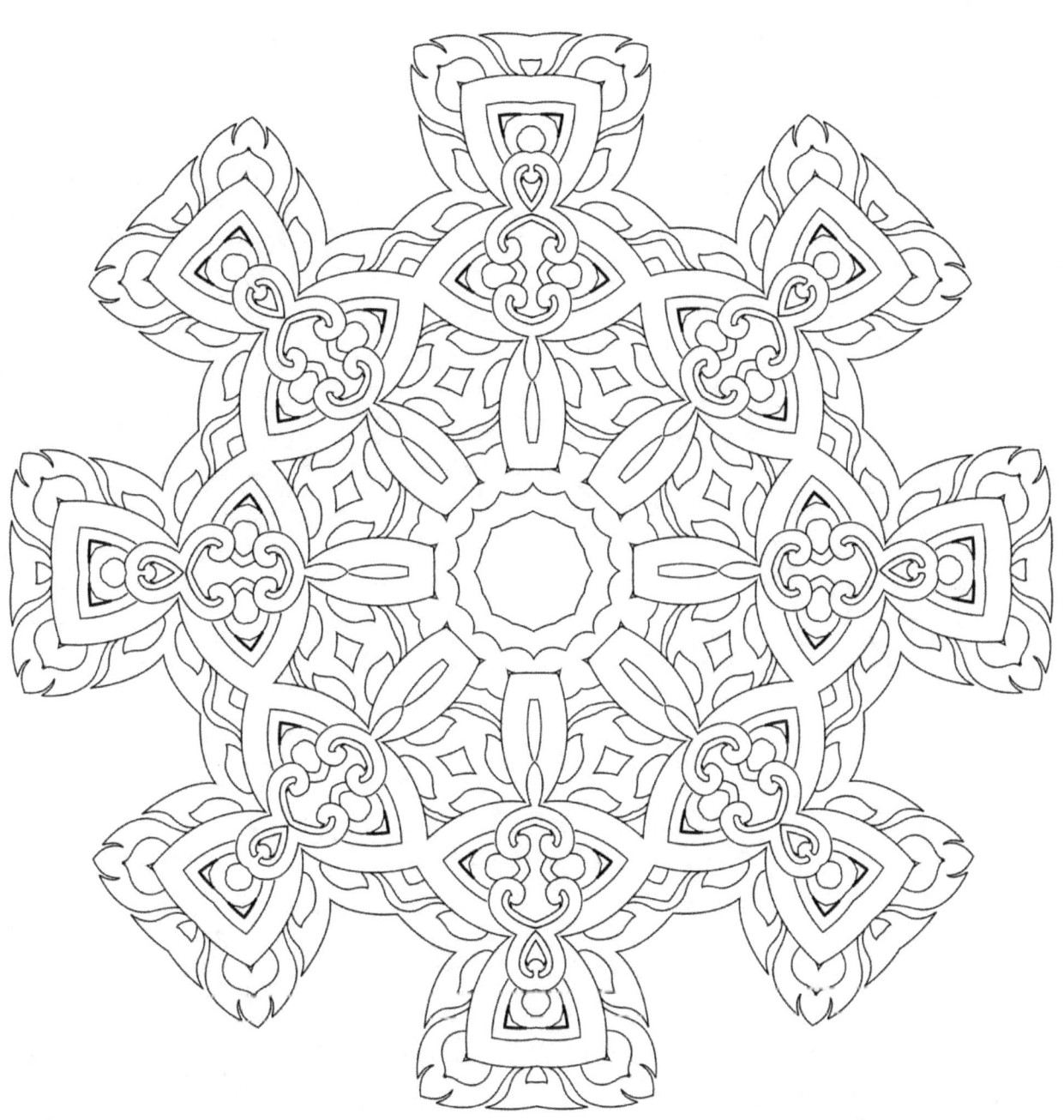

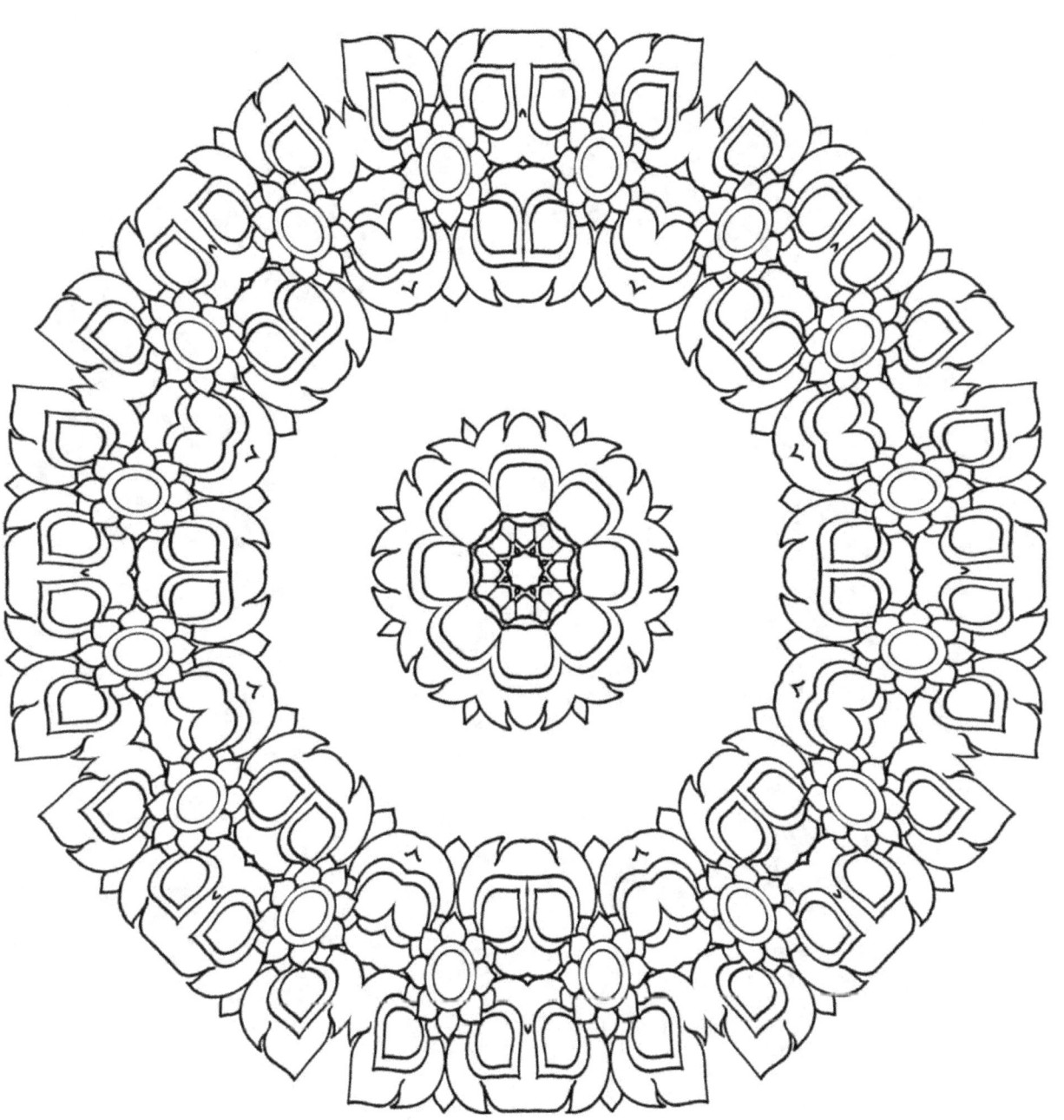

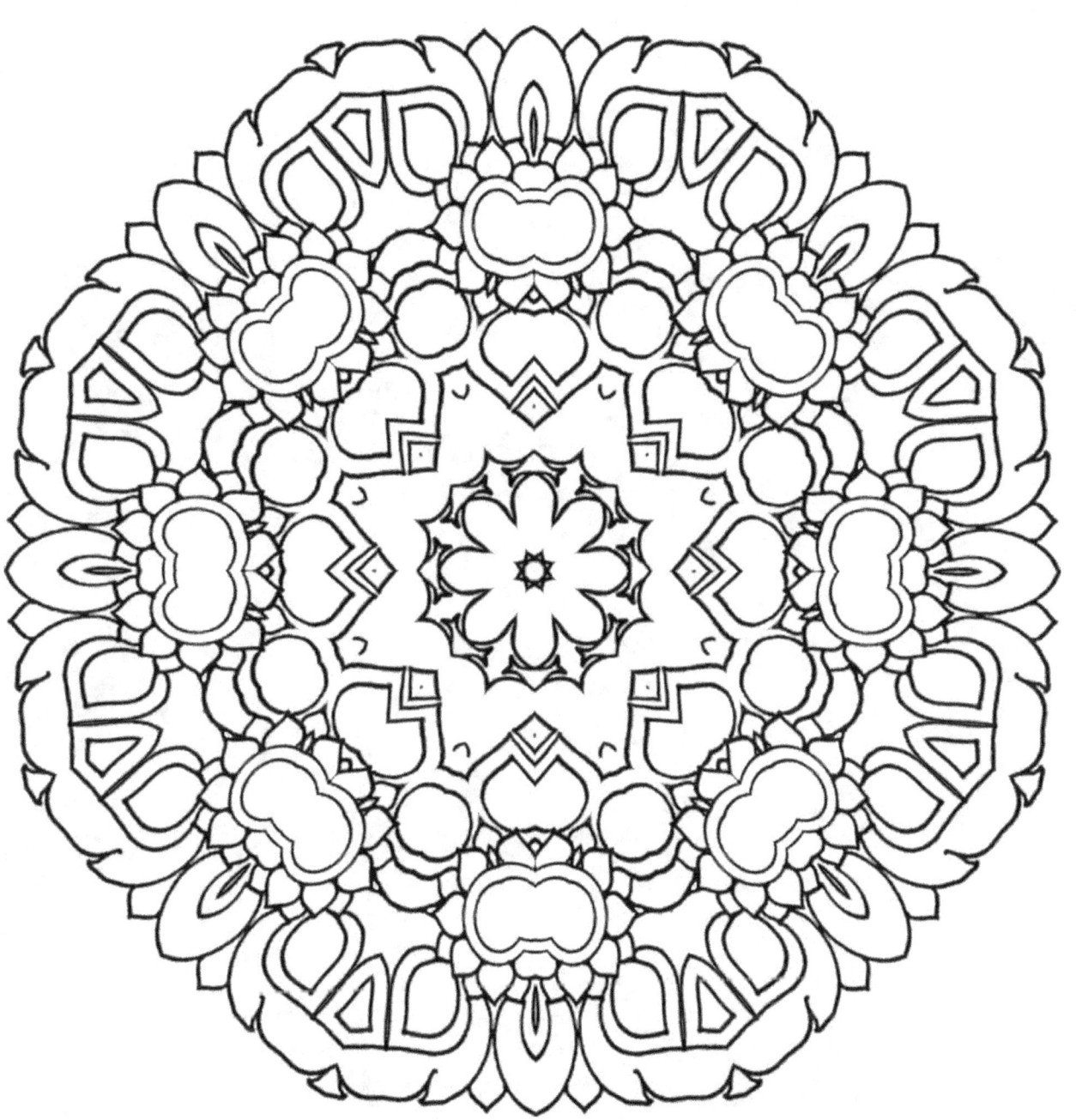

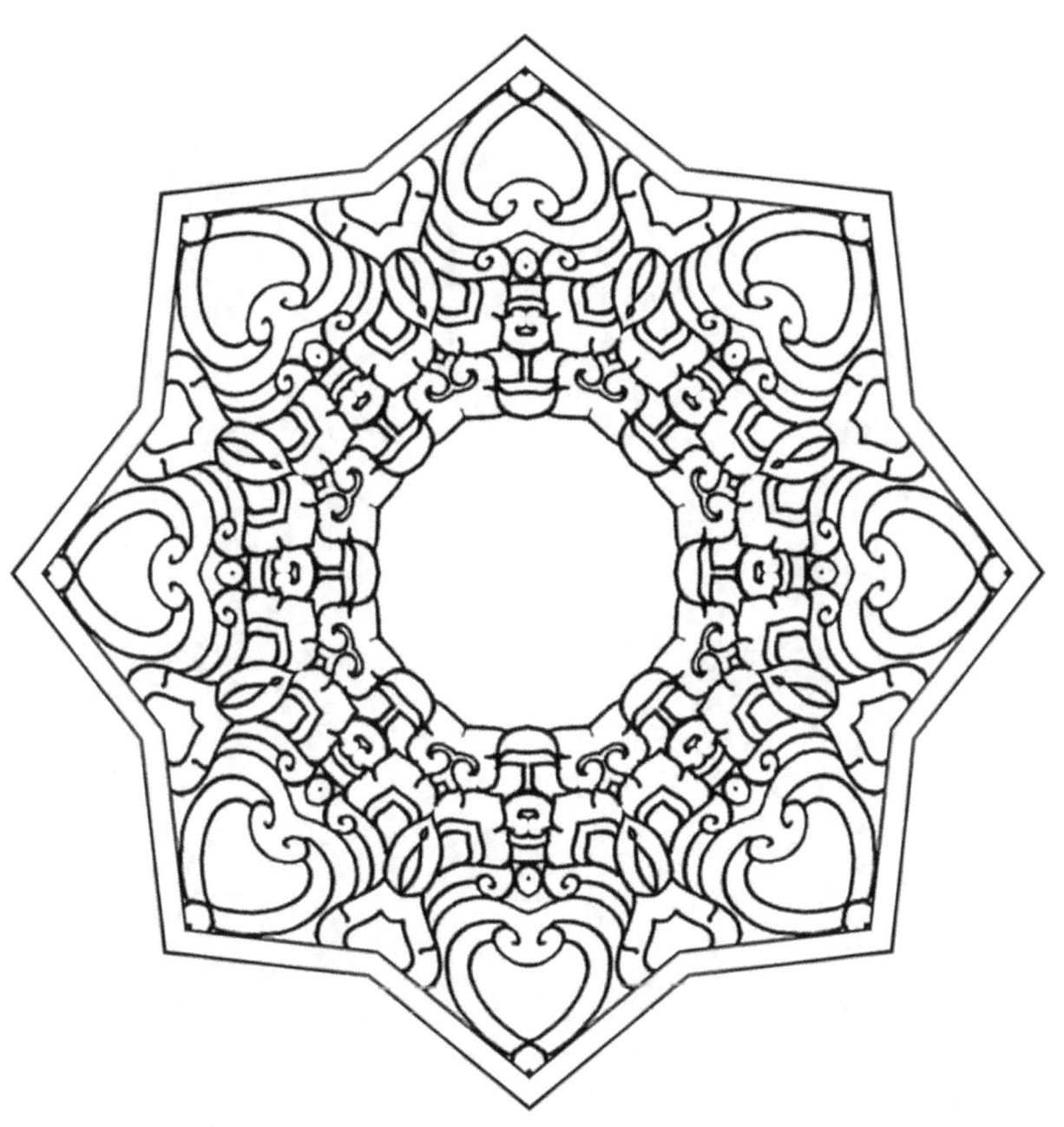

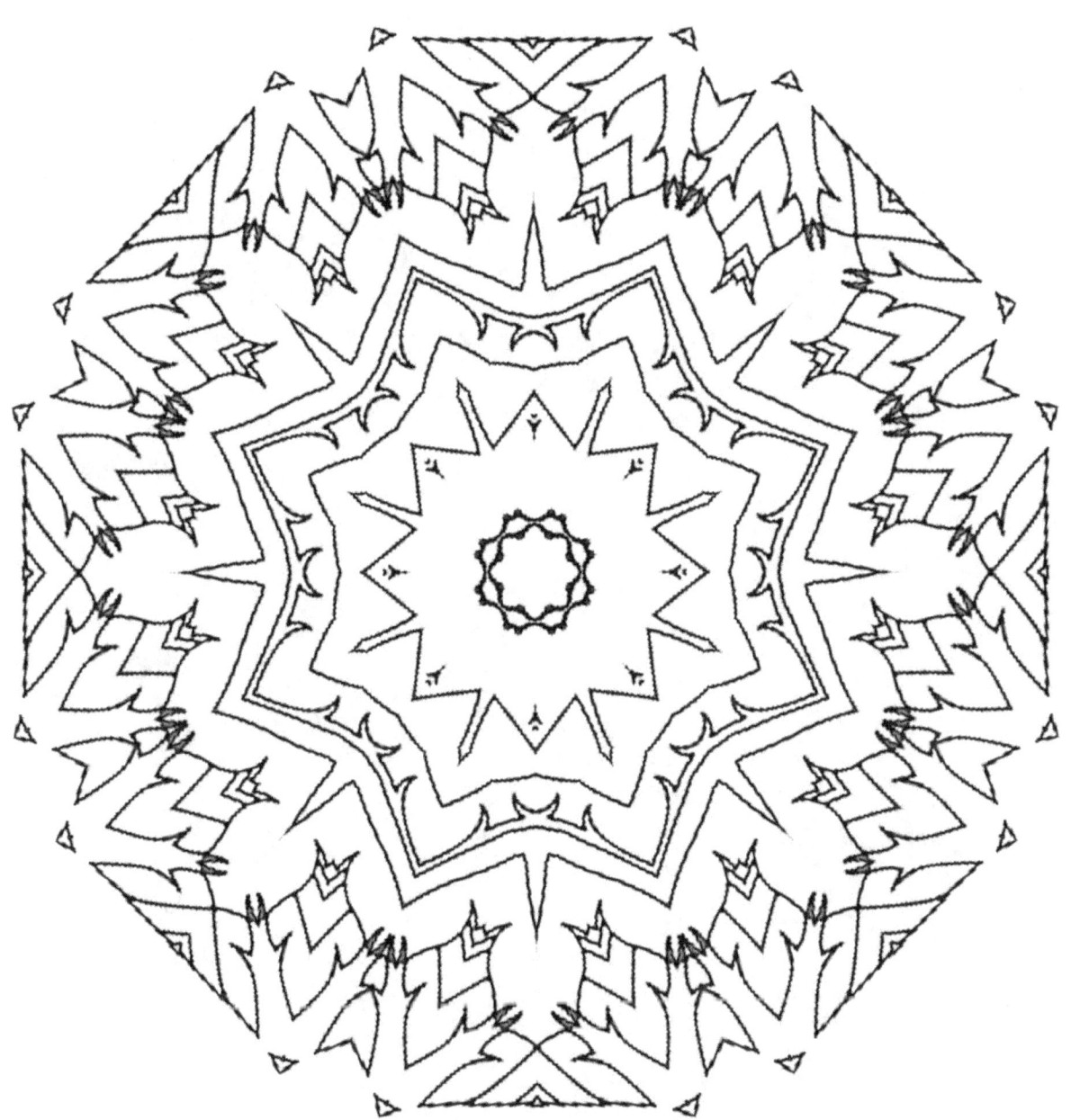

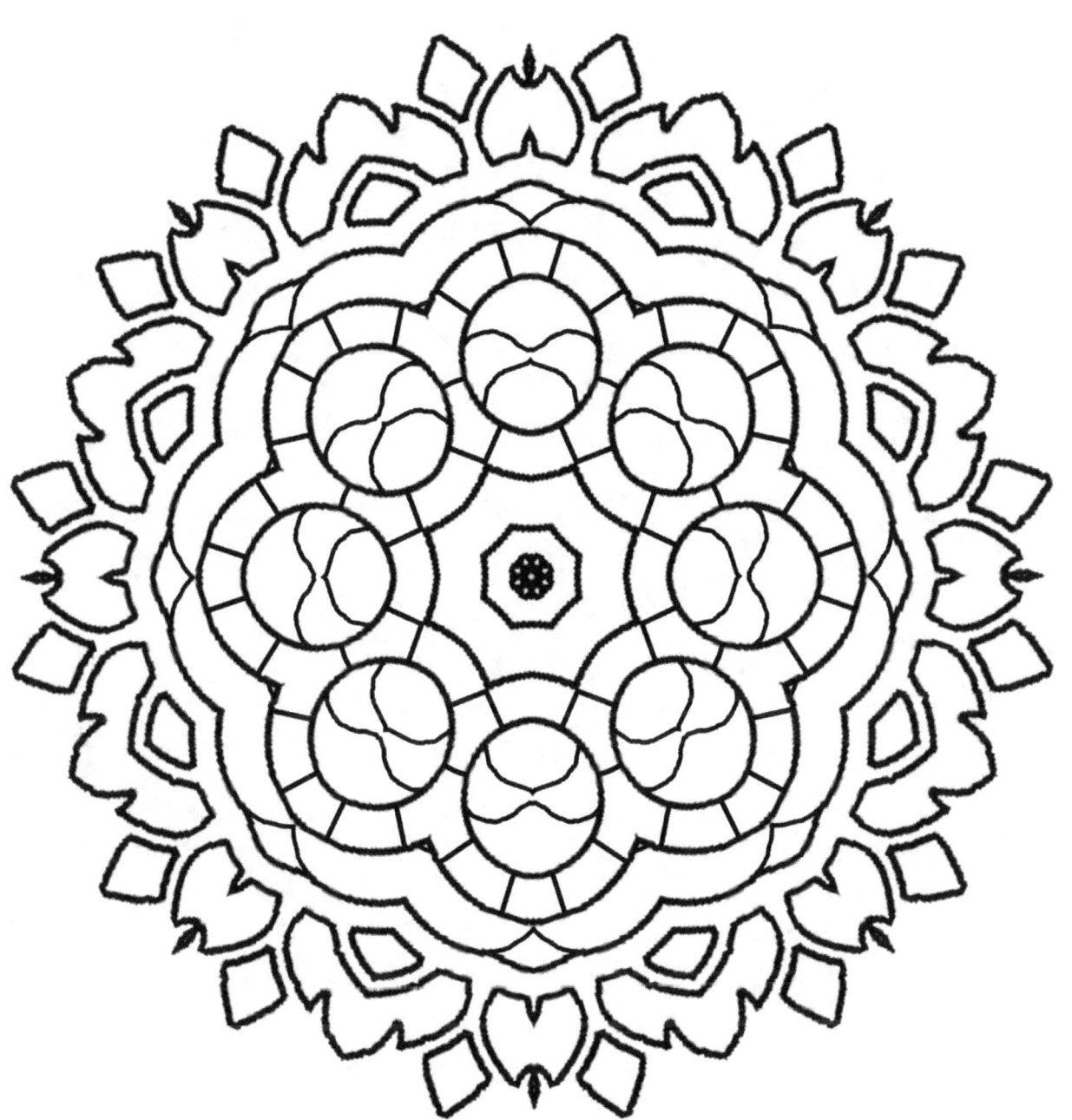

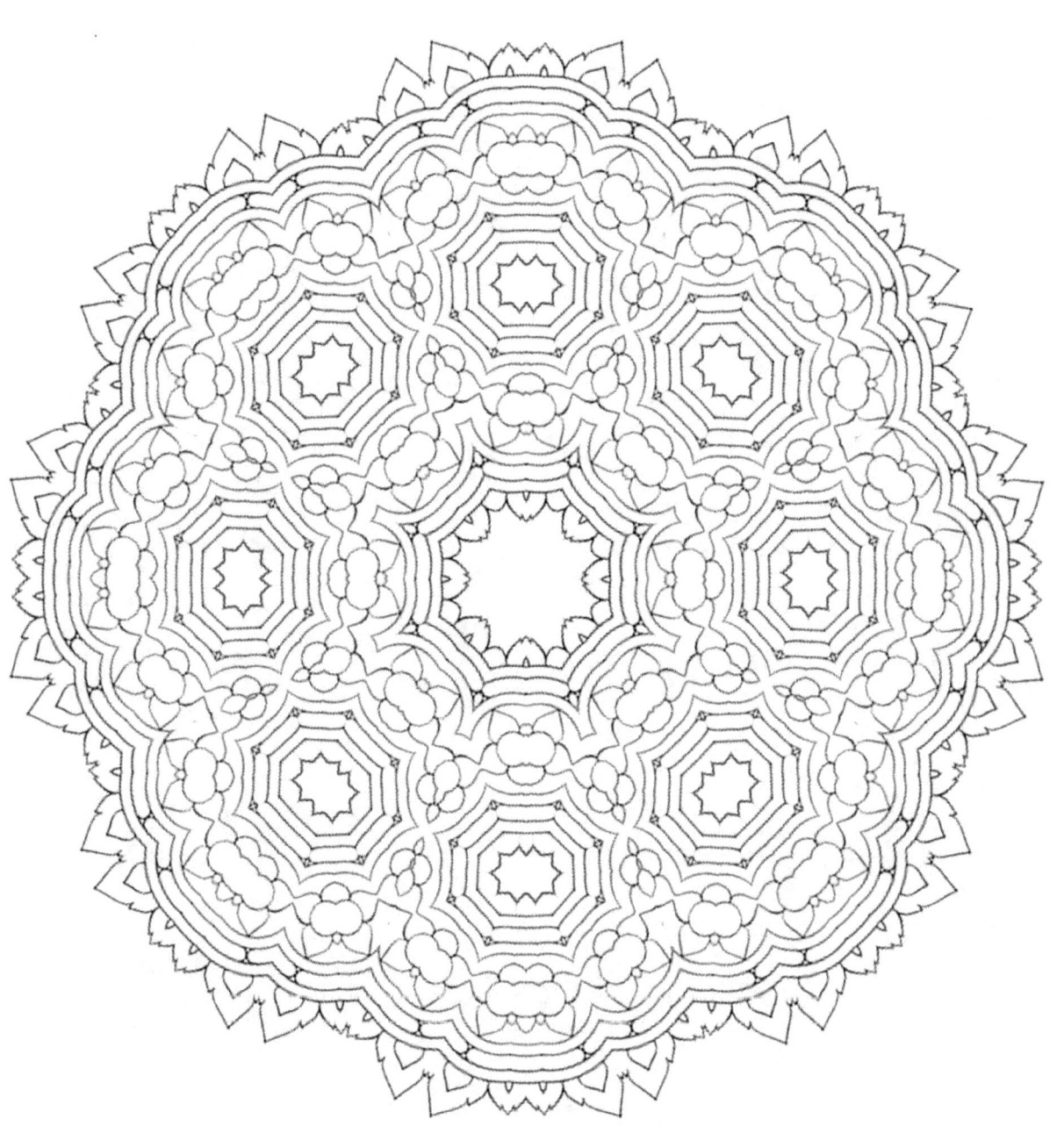

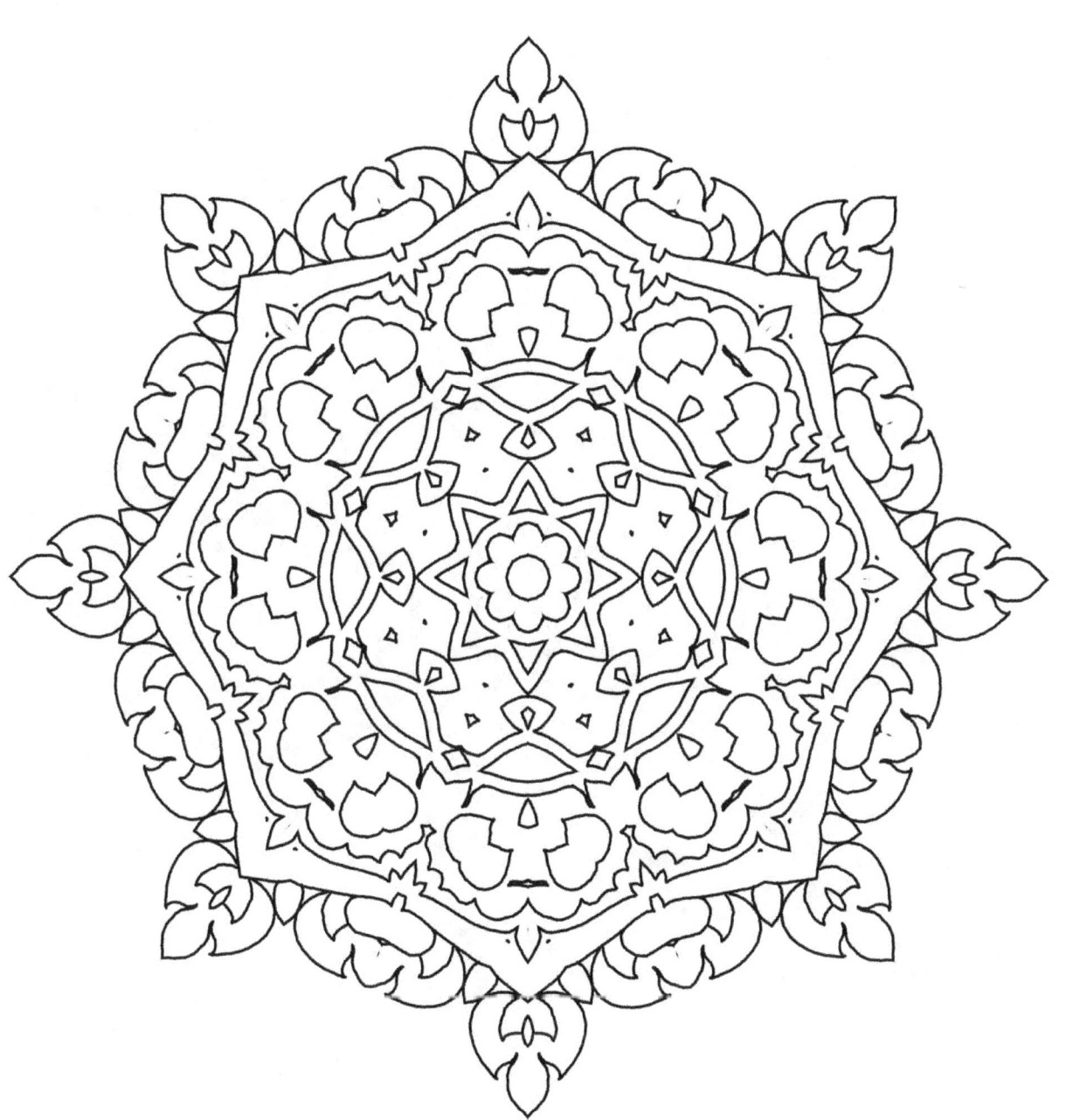

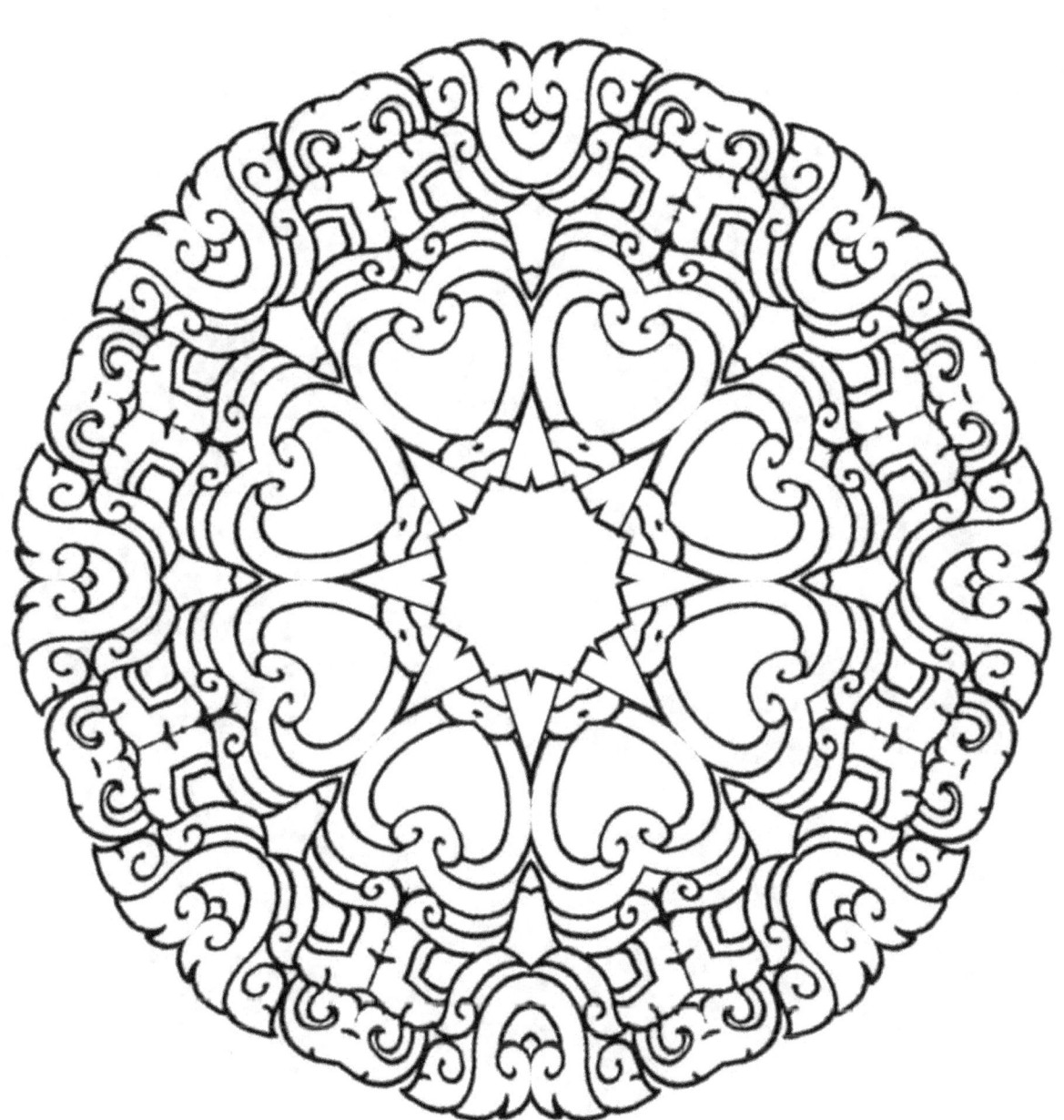

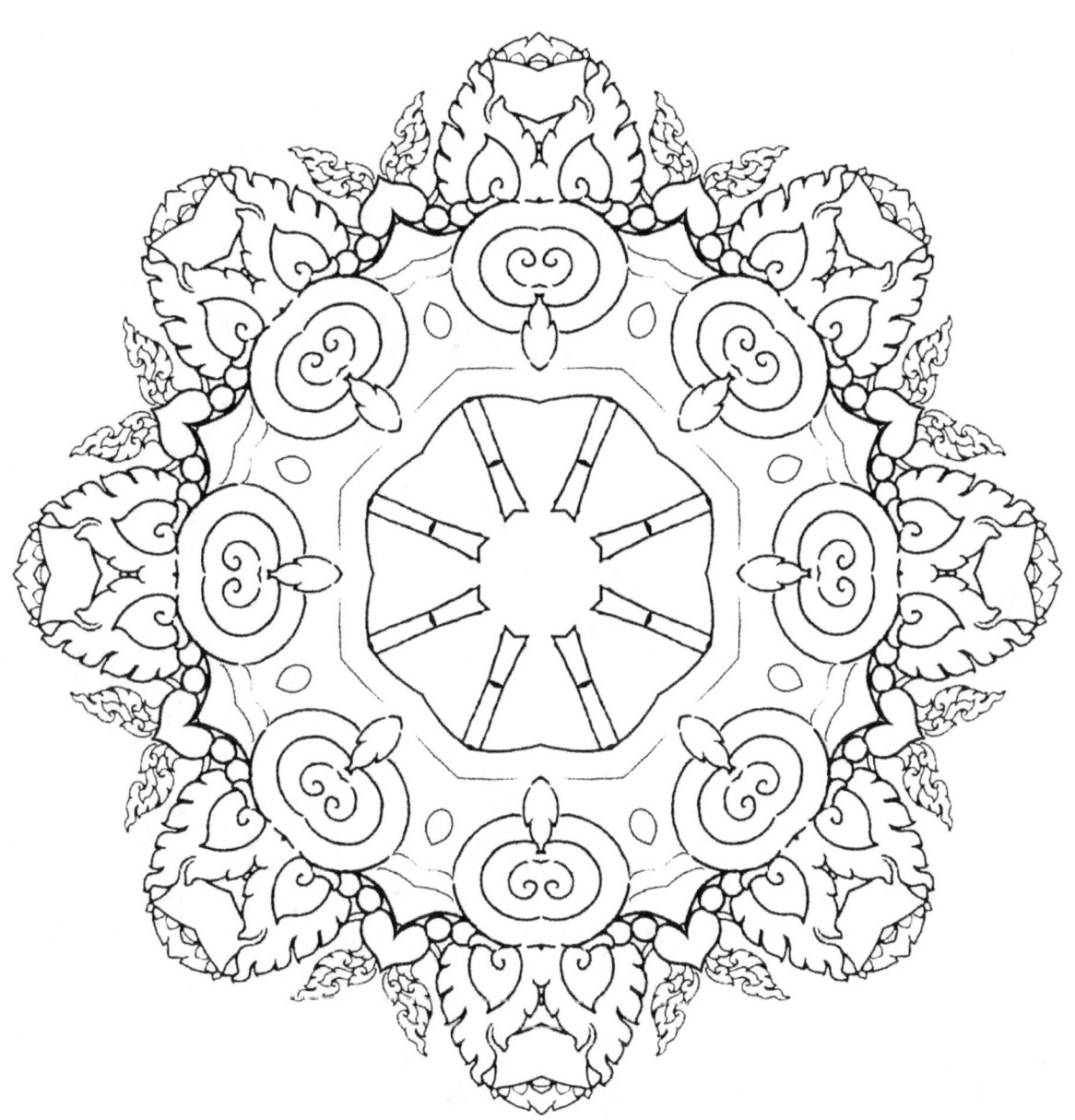

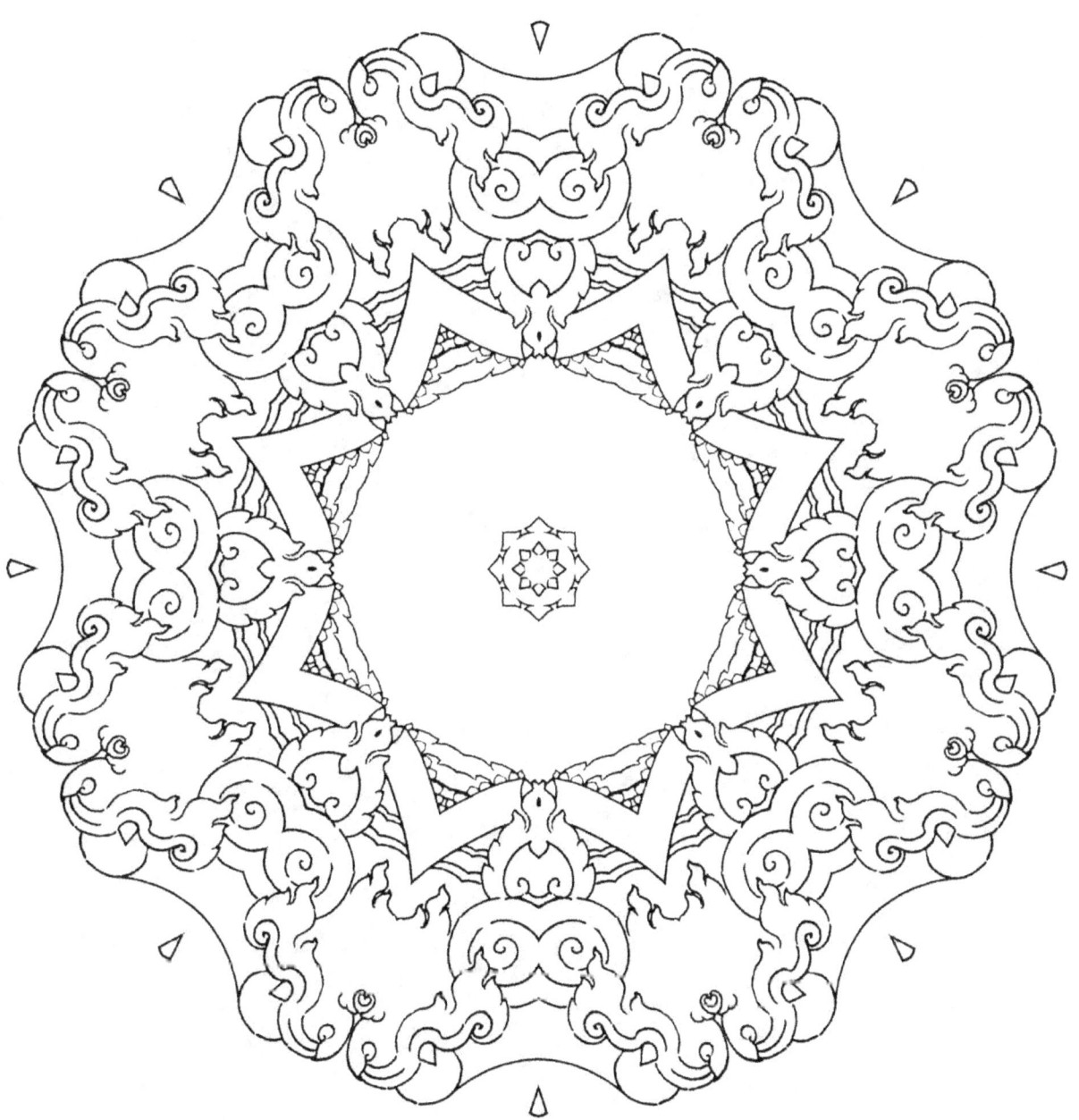

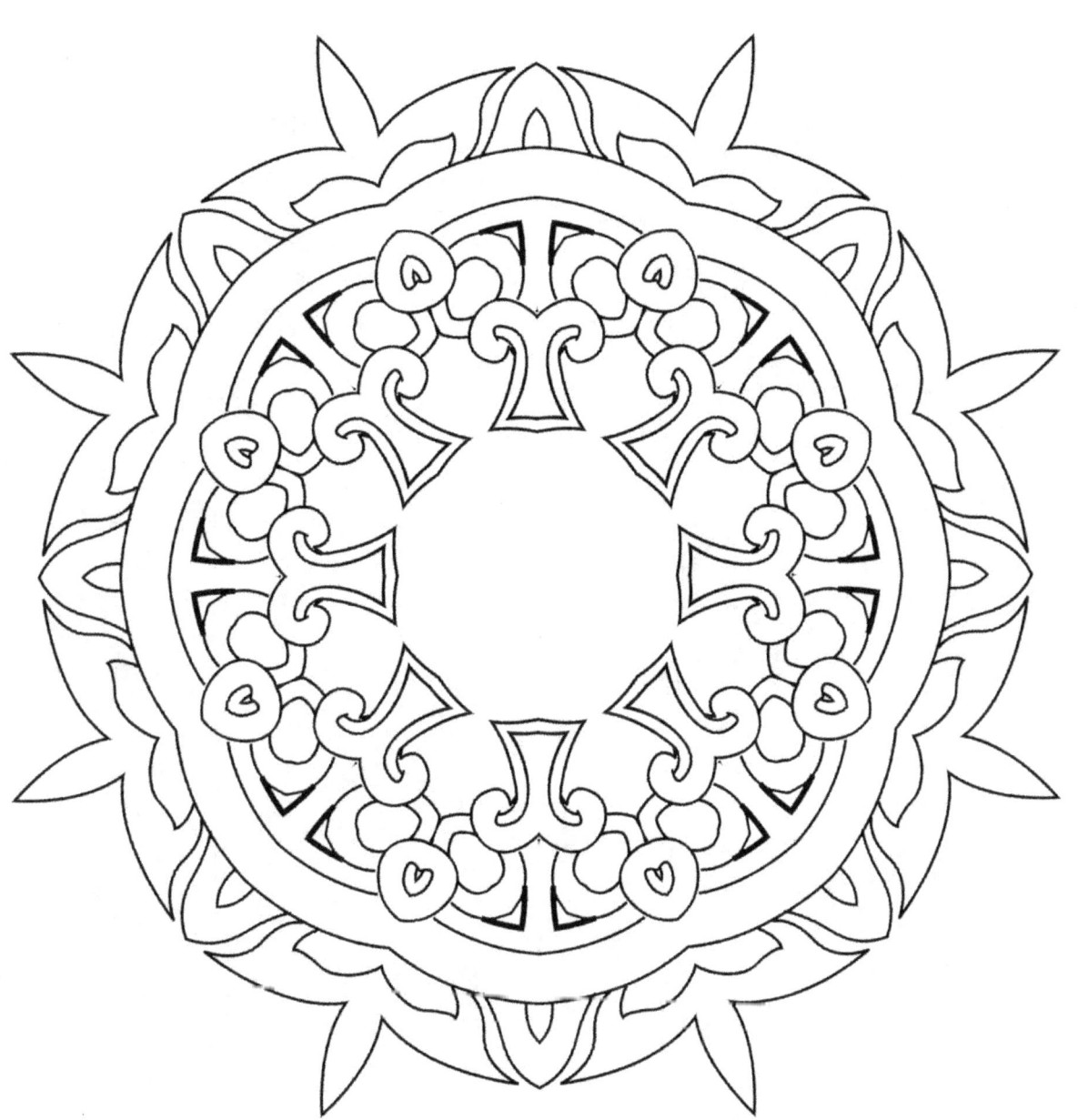

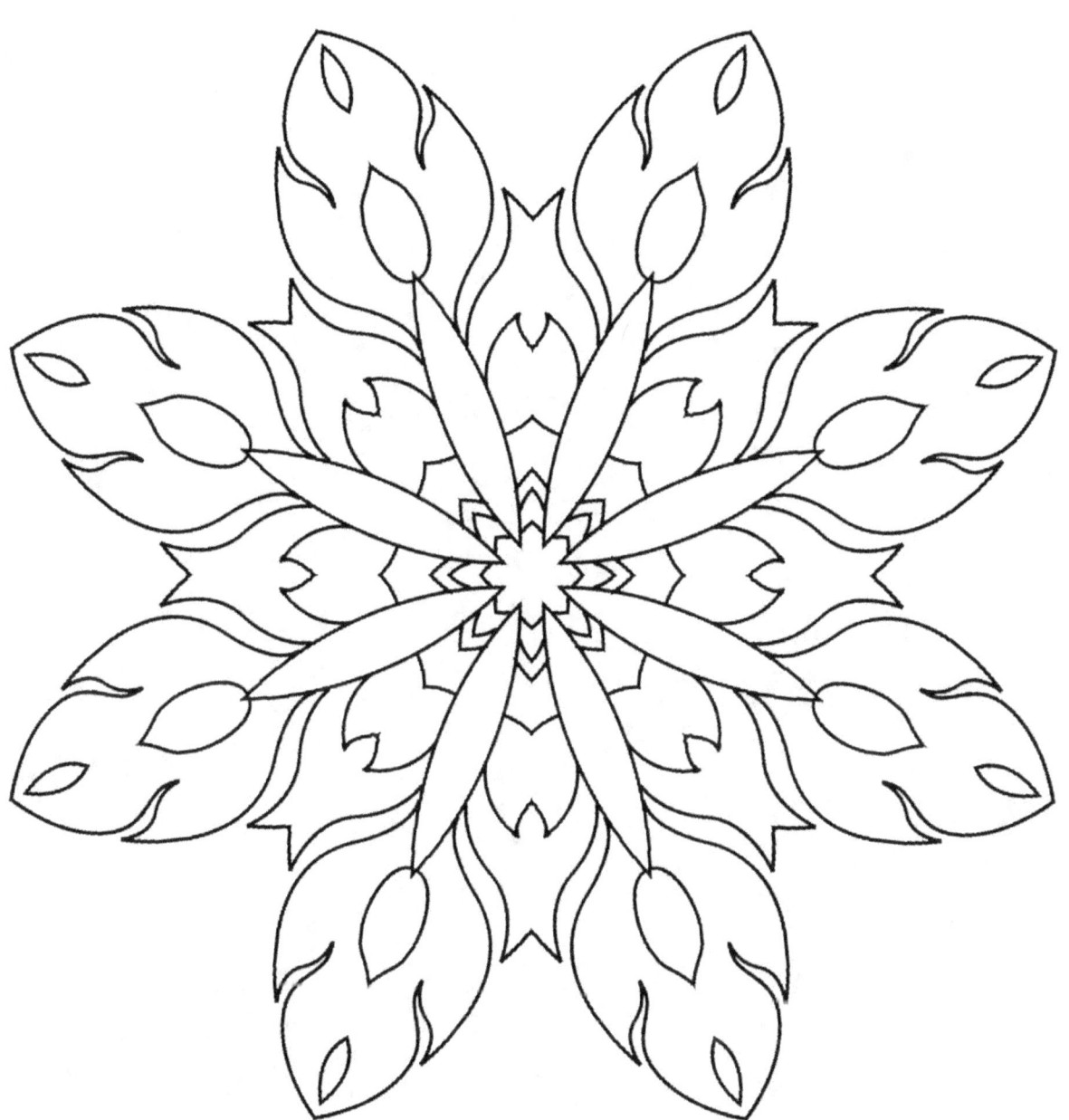

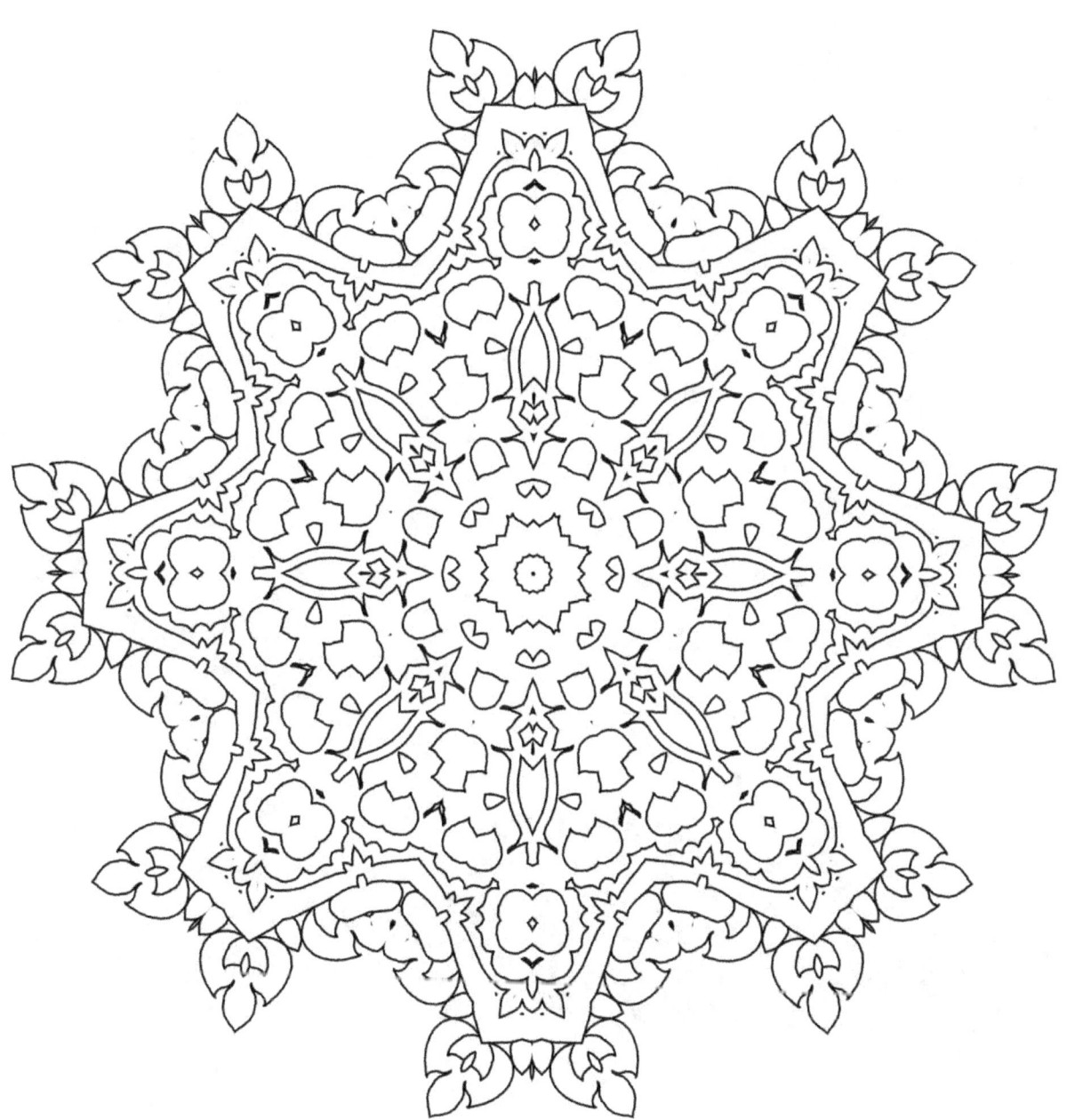

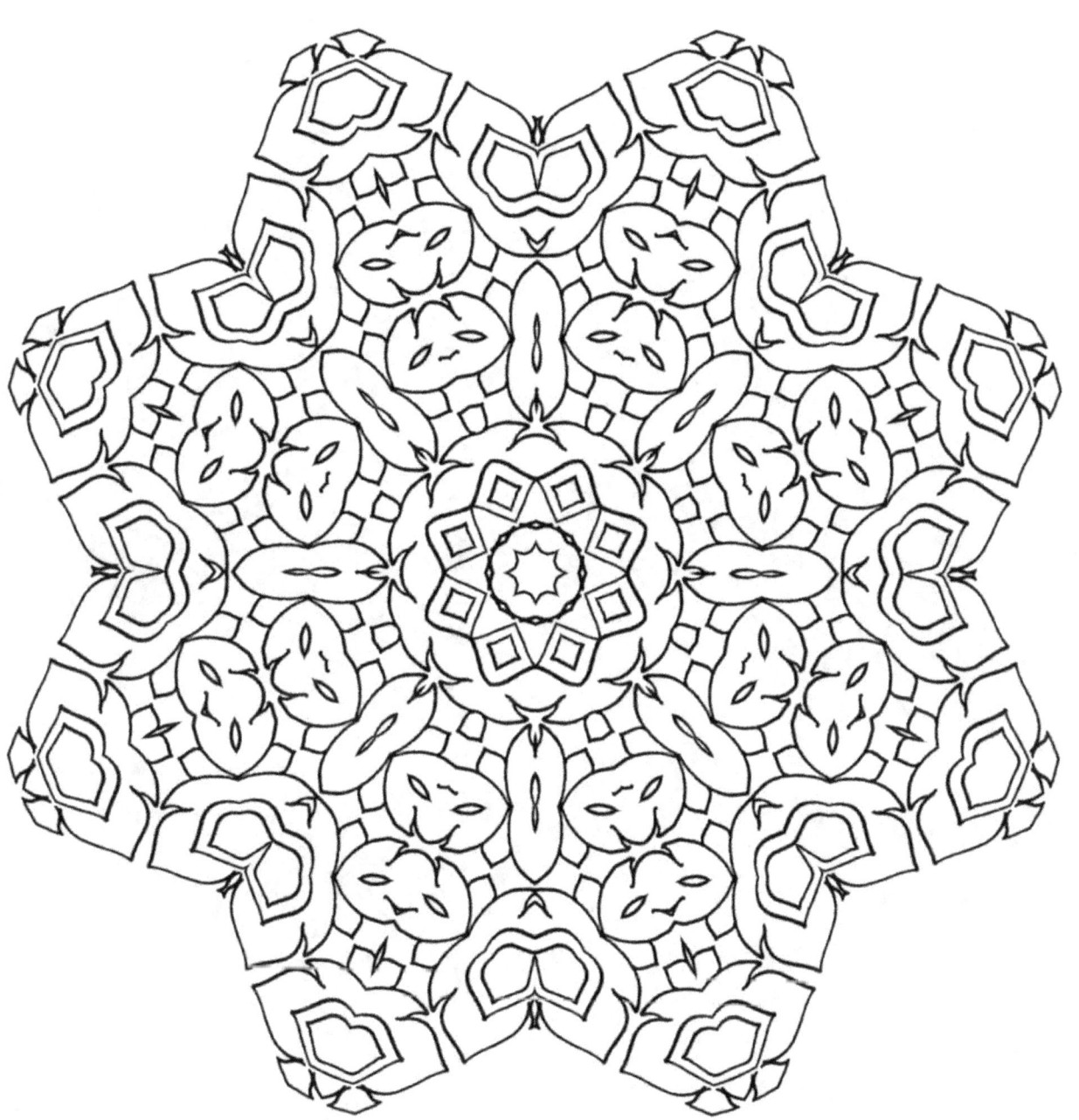

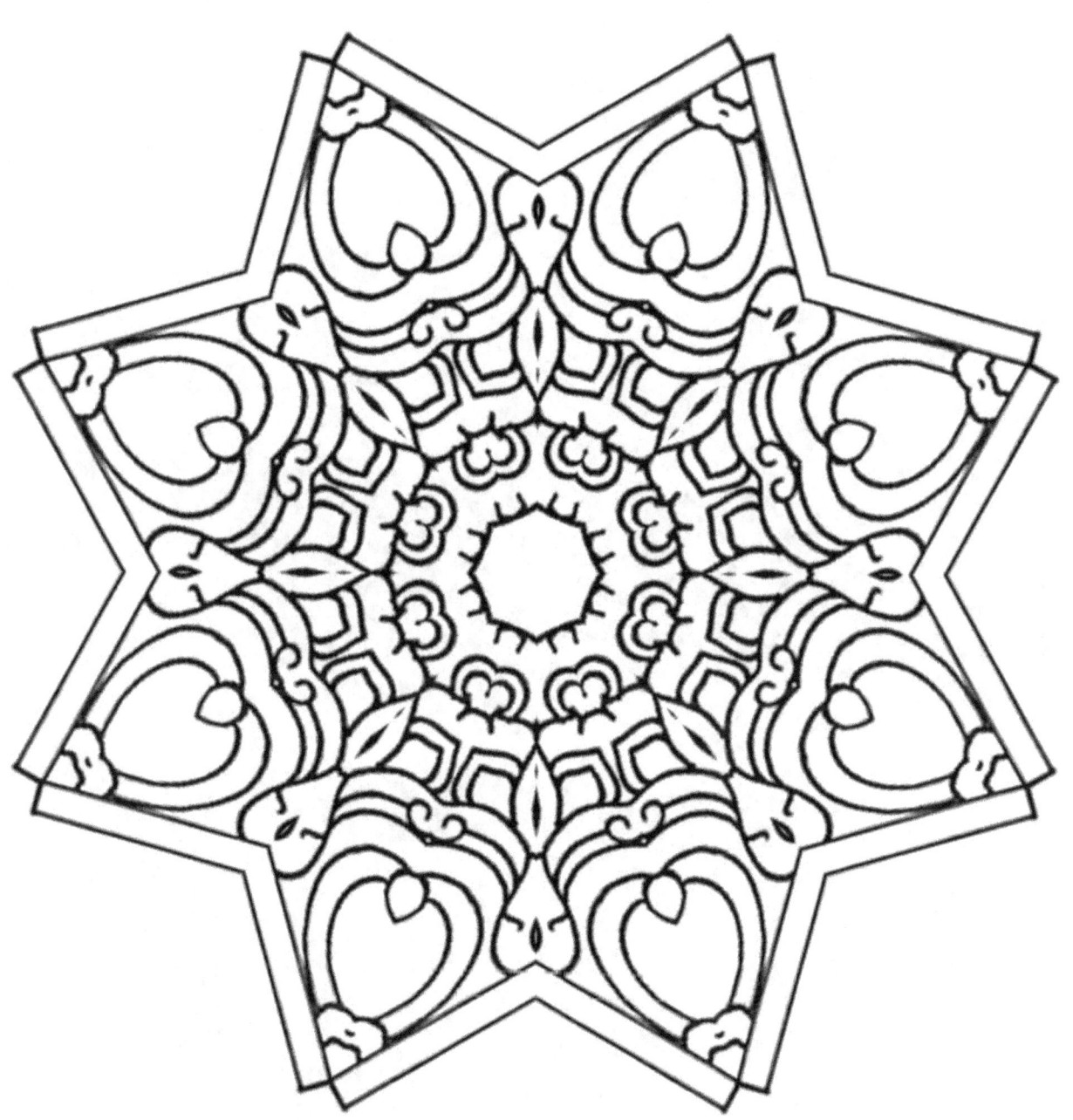

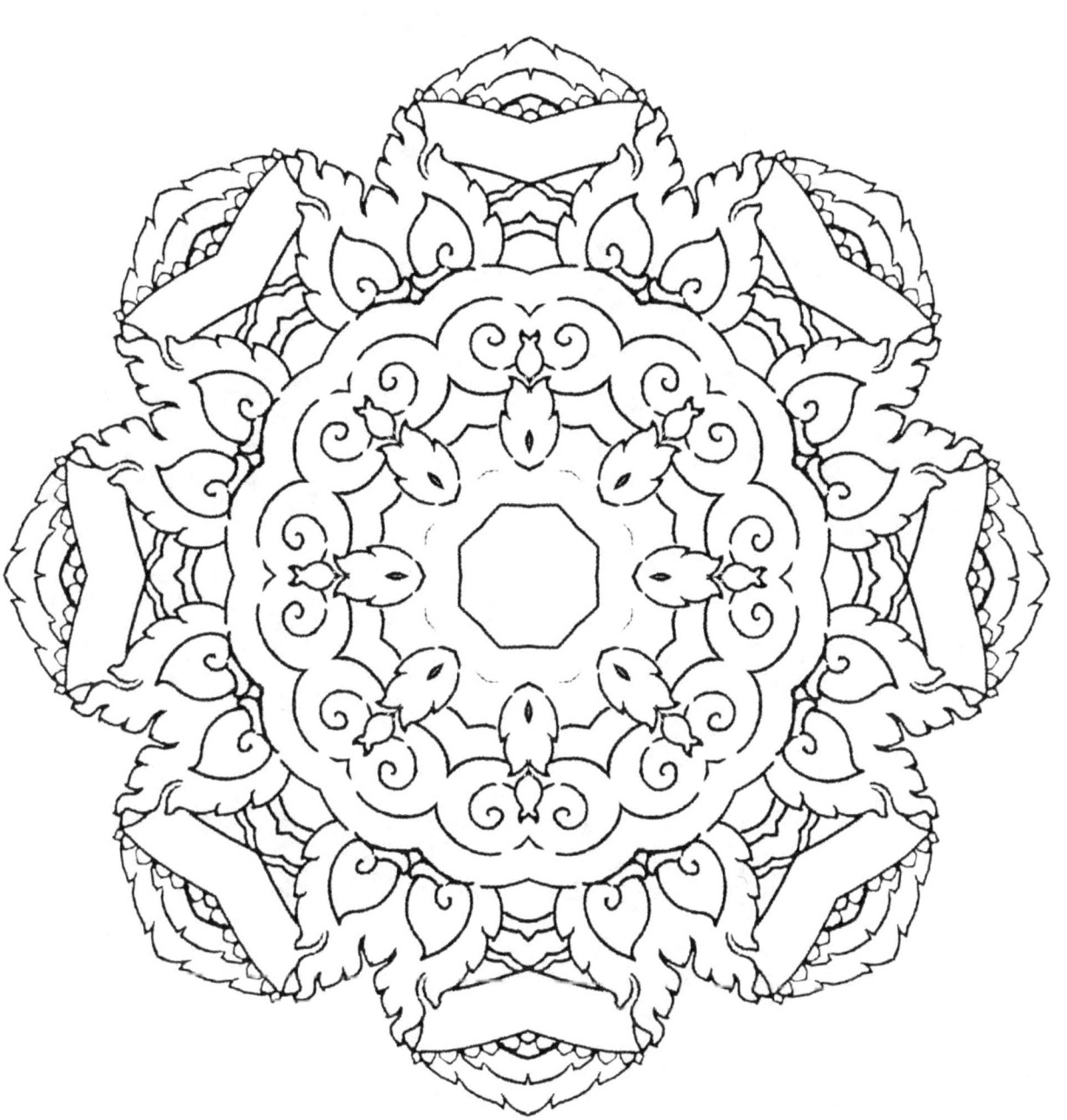

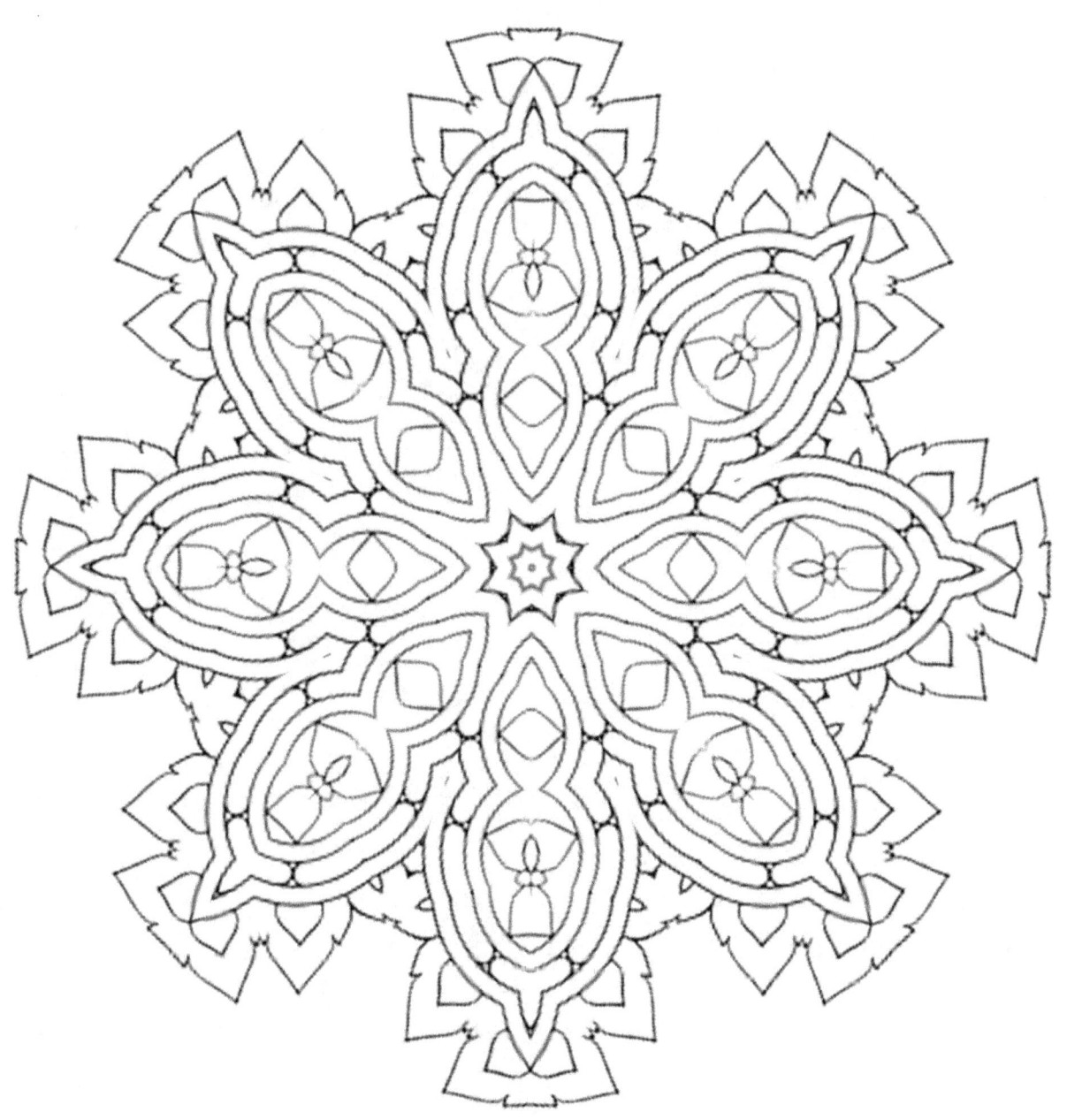

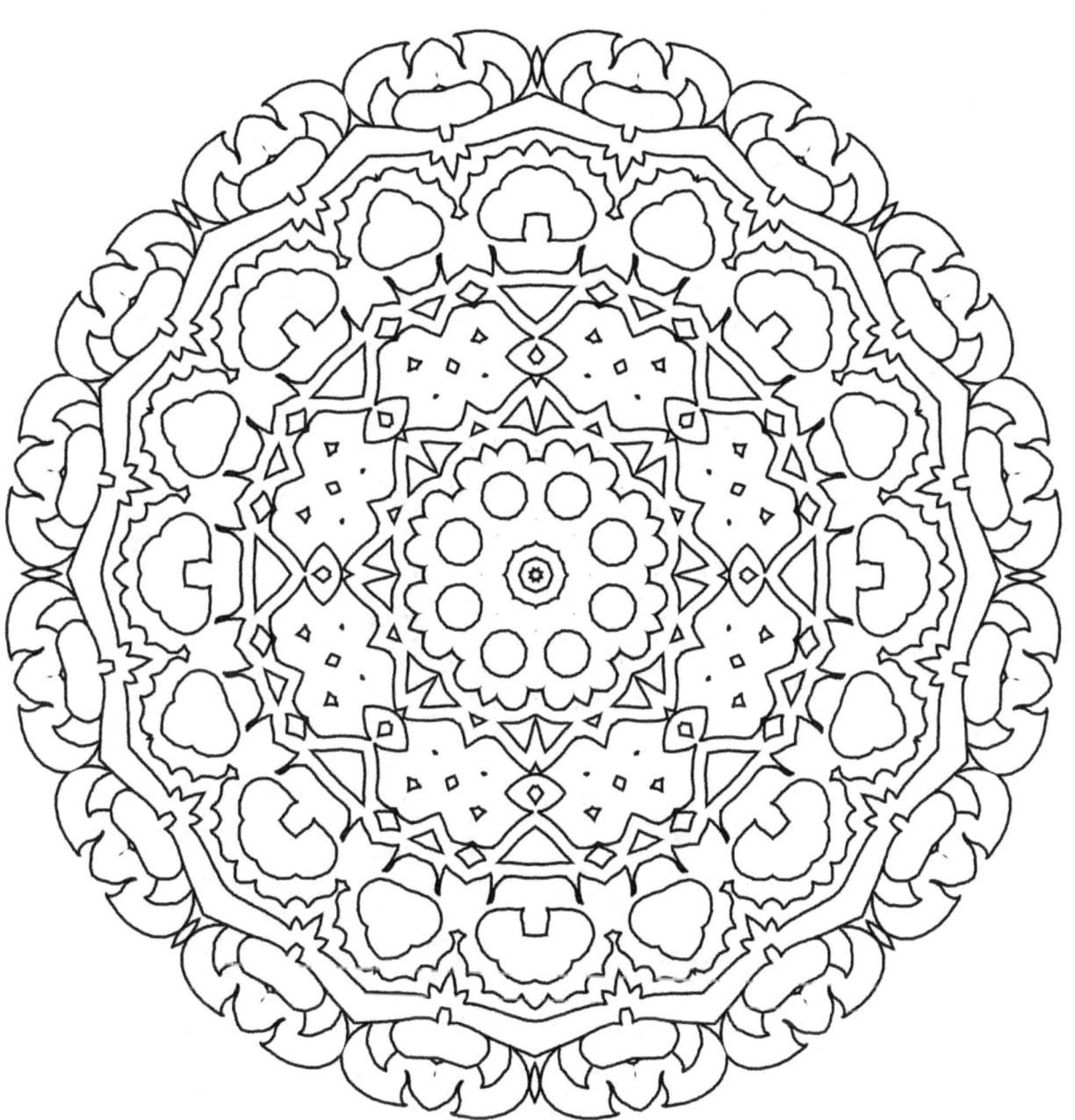

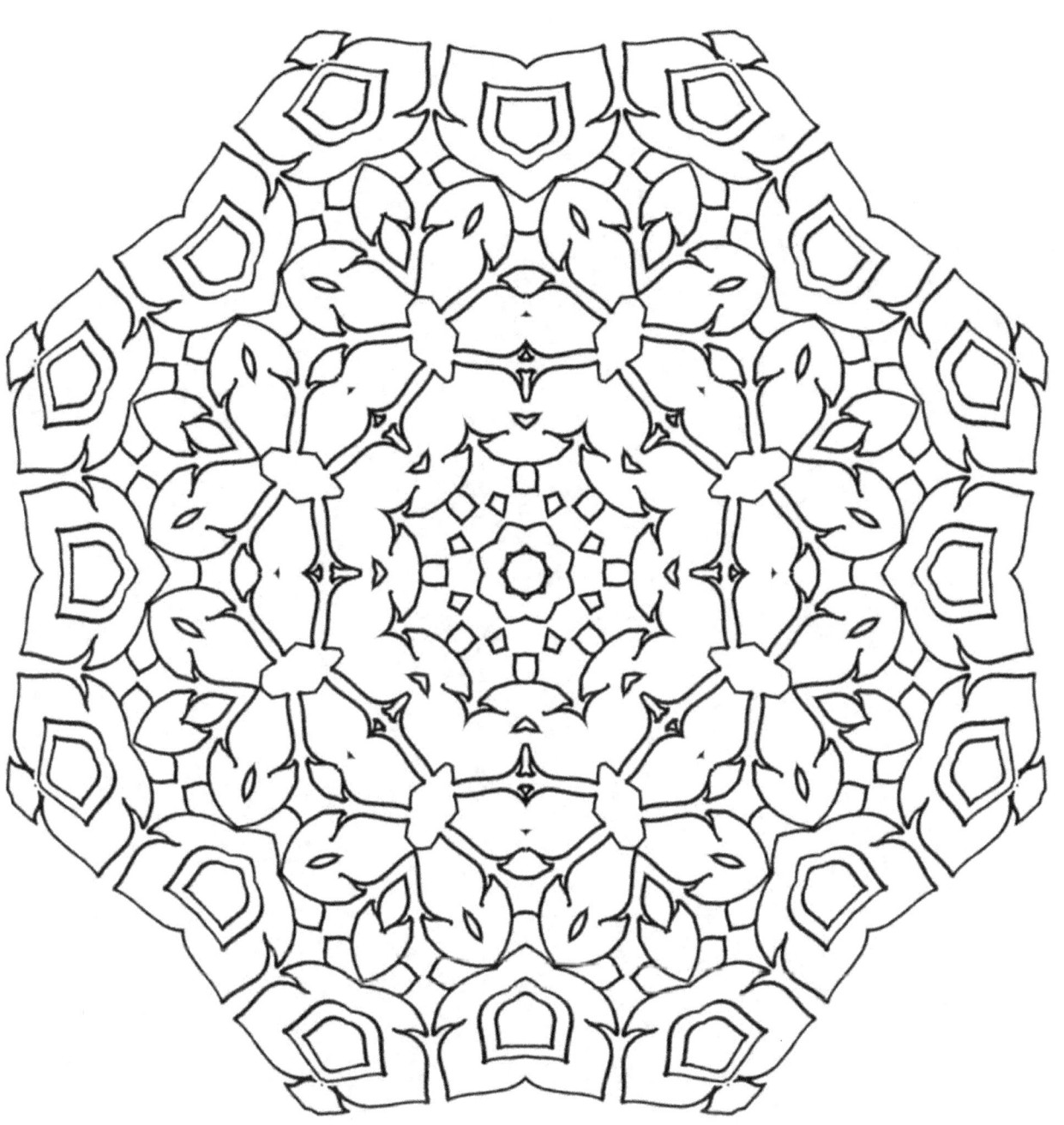

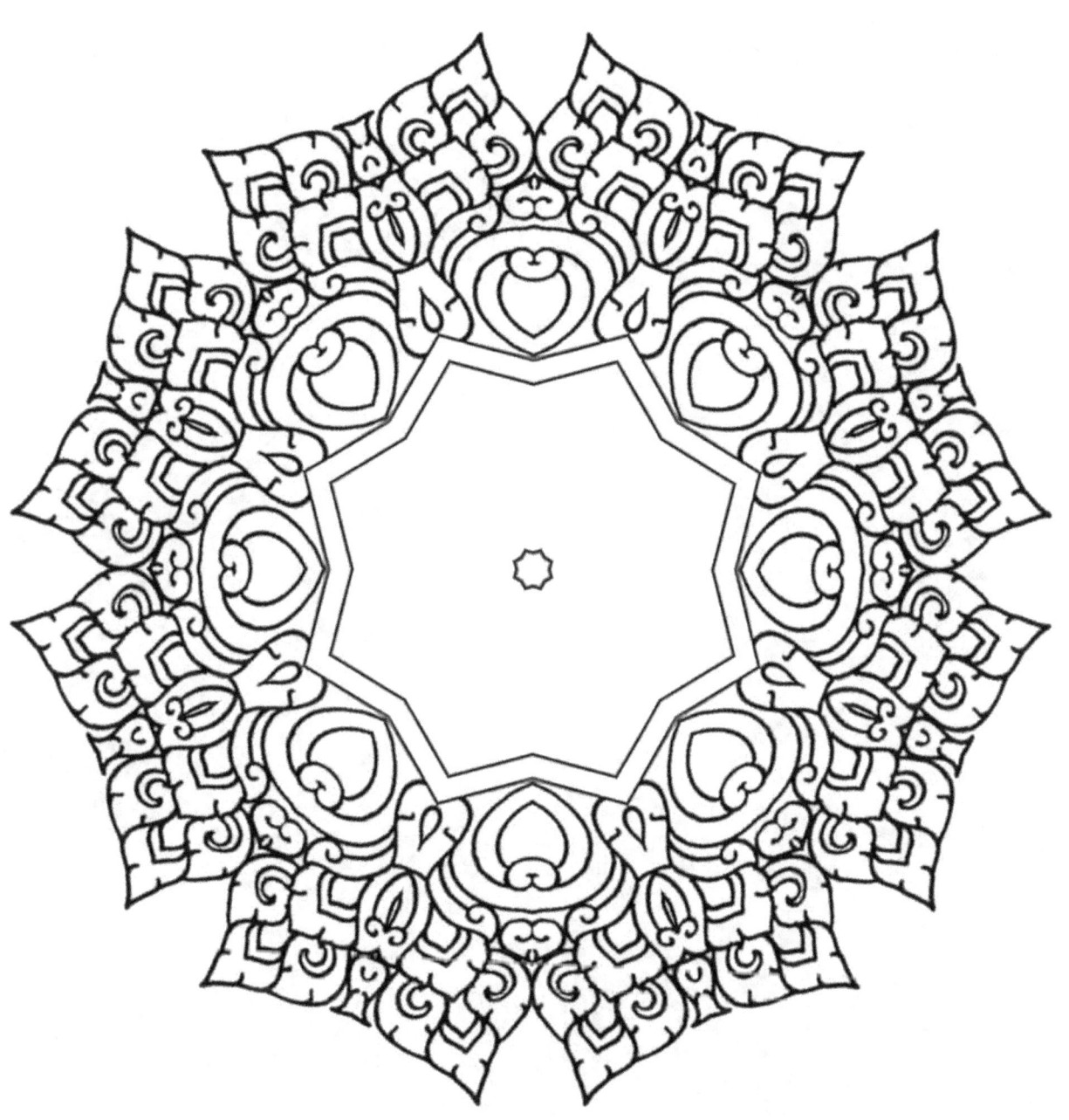

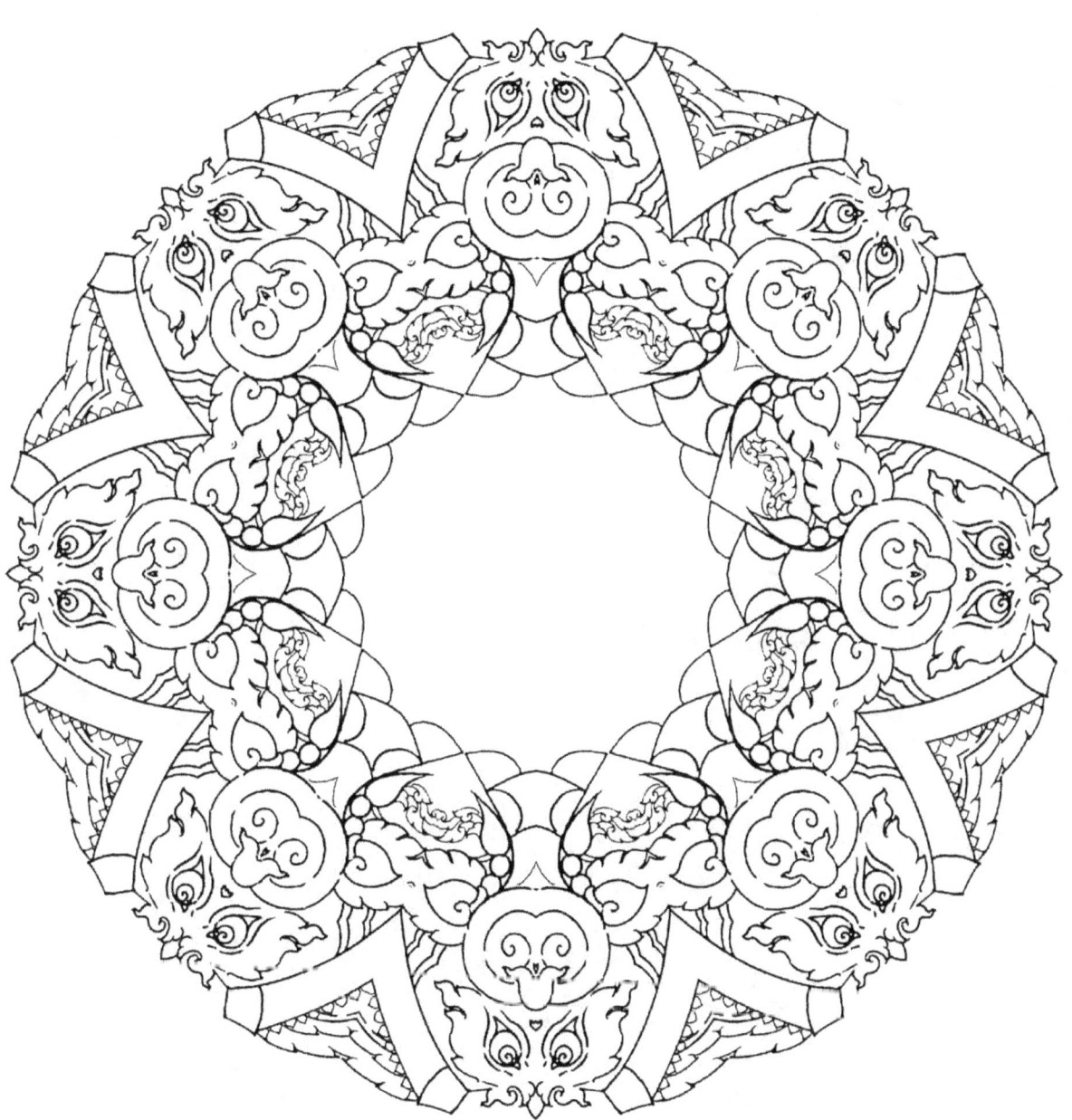

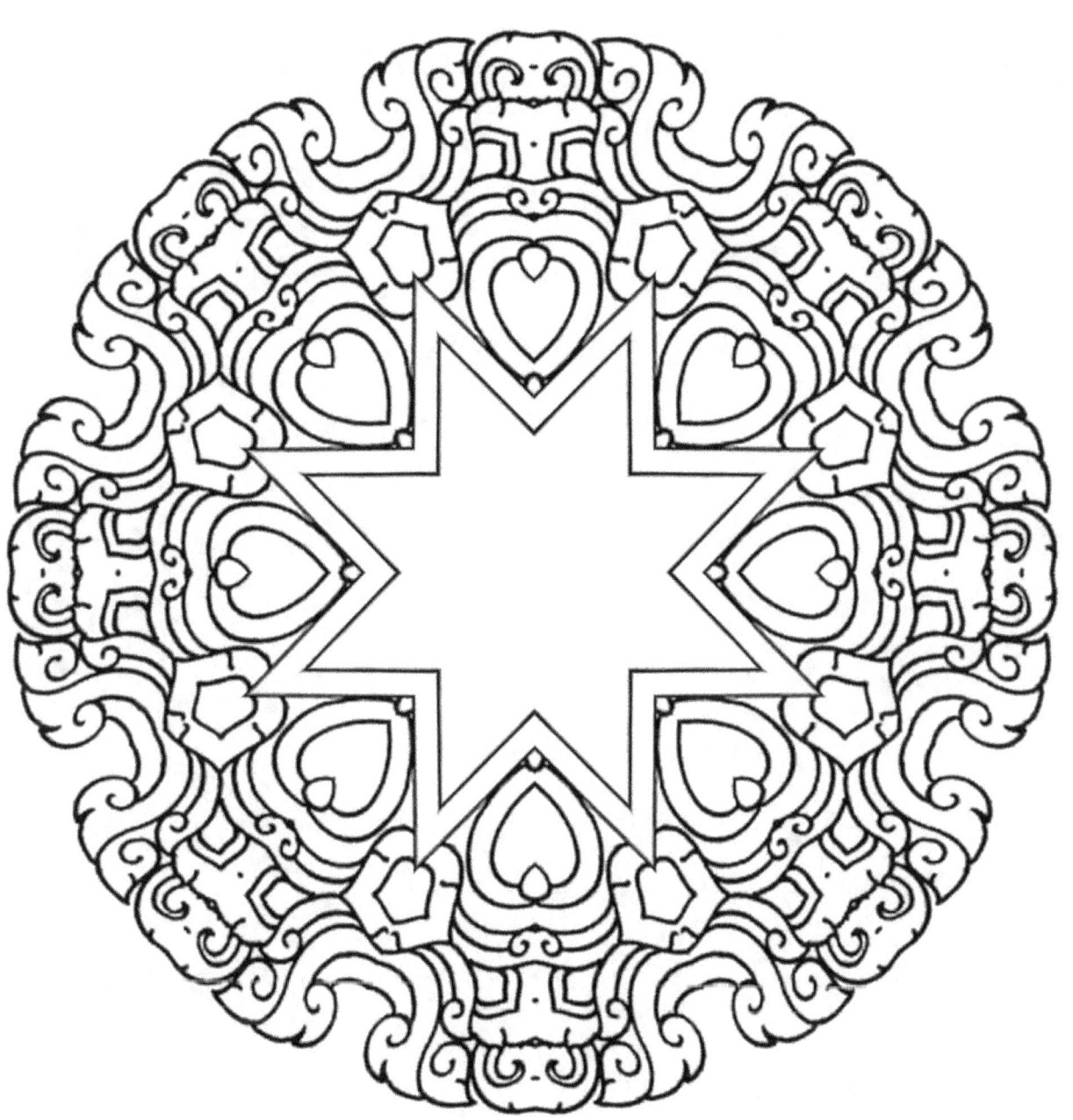

Thank you

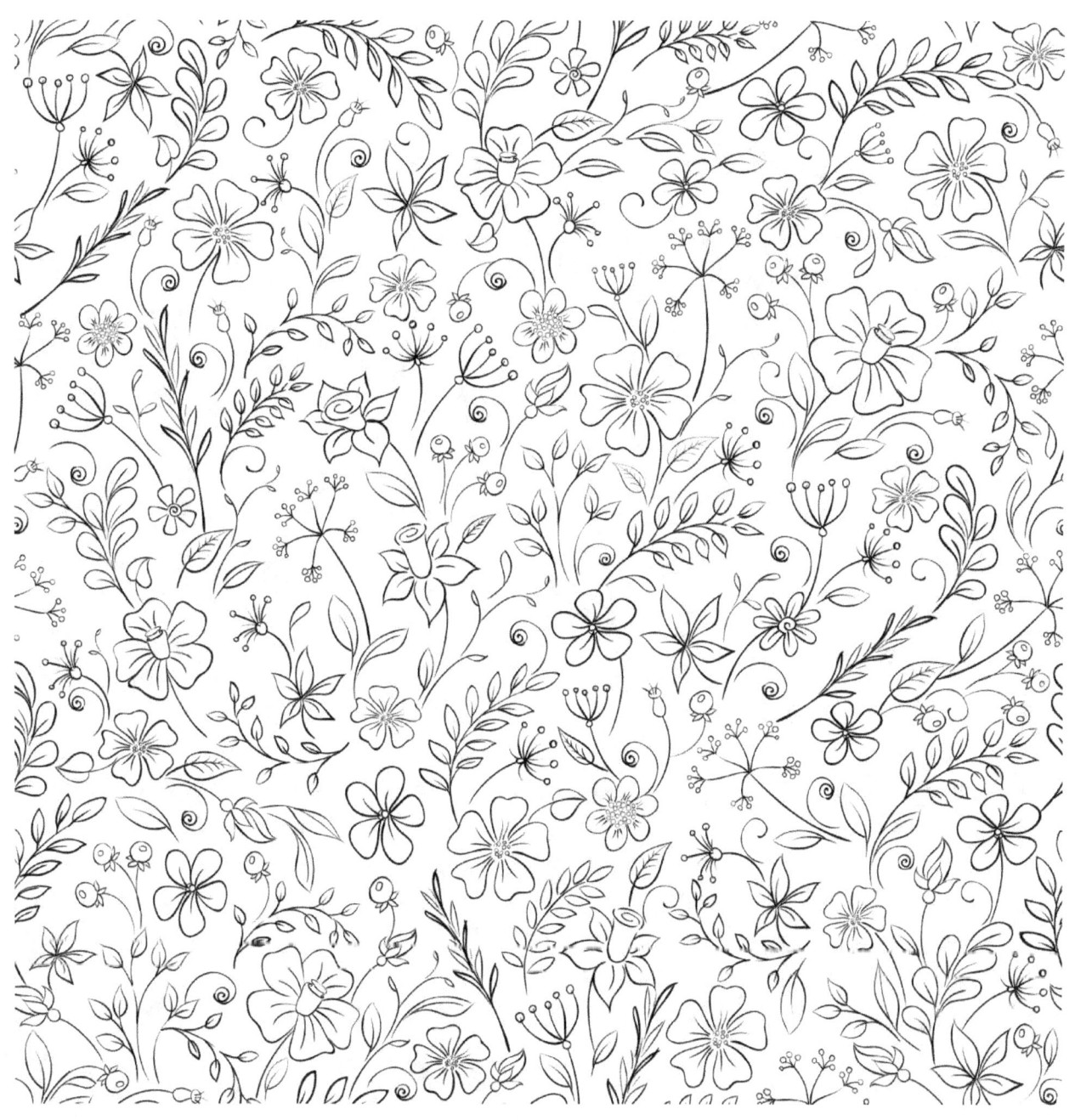

www.ingramcontent.com/pod-product-compliance
Lightning Source LLC
Chambersburg PA
CBHW081116180526
45170CB00008B/2873